ai

Foreword by Yoko Ono

Japan through John Lennon's Eyes

A Personal Sketchbook

—

John Lennon

Cadence Books, San Francisco

First United States Edition, 1992
10 9 8 7 6 5 4 3 2 1

Executive Editor: Seiji Horibuchi
Managing Editor: Satoru Fujii
Book Design: Shinji Horibuchi and Somei Shinnishi
Publisher: Masahiro Oga

Library of Congress Cataloging-in-Publication Data
Lennon, John, 1940–
 Ai : Japan through John Lennon's eyes : a personal sketchbook/
John Lennon : foreword by Yoko Ono.—1st U.S. ed.
 p. cm.
 "Originally published in 1990 as ai : Japan through John Lennon's
eyes by Shogakukan, Inc., Tokyo, Japan"—T.p. verso.
 ISBN 0-929279-78-6
 1. Japanese language—Terms and phrases. 2. Lennon, John. 1940–
—Notebooks, sketchbooks, etc. I. Title.
PL539.L37 1992
428.2′421—dc20 91–18286
 CIP

Originally published in 1990 as *ai: Japan through John Lennon's Eyes*
by Shogakukan, Inc., Tokyo, Japan

Editors: Makoto Nagano, Shuji Shimamoto, and Dave Spector
Art Director: Yukimasa Okumura

Cadence Books
Division of Viz Communications, Inc.
P.O. Box 77010
San Francisco, California 94107

Printed in Japan

Foreword

This book was named *ai* (pronounced "eye") because that was how John viewed and experienced Japan—with love. I also thought it would be nice if, as a result of this, the world would learn a Japanese word that was closer to John's heart than words such as *sayonara* (good-bye) and *shogun* (chief commander).

This book shows how John studied the Japanese language. Leafing through the pages, you will see the hilarious images that came to his mind. I hope you will enjoy this book. Maybe you'll learn a few words, too. More importantly, I hope John, through this book, will teach you how to face a new world—with a sense of fun and a lot of love.

yoko

September 1990
NYC

Contents

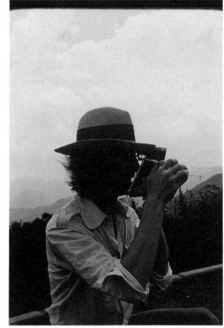

Photo by Y.O.

1

Myself

自分
jibun

myself

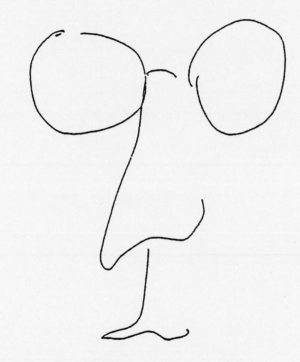

JIBUN

詩人
shijin

poet

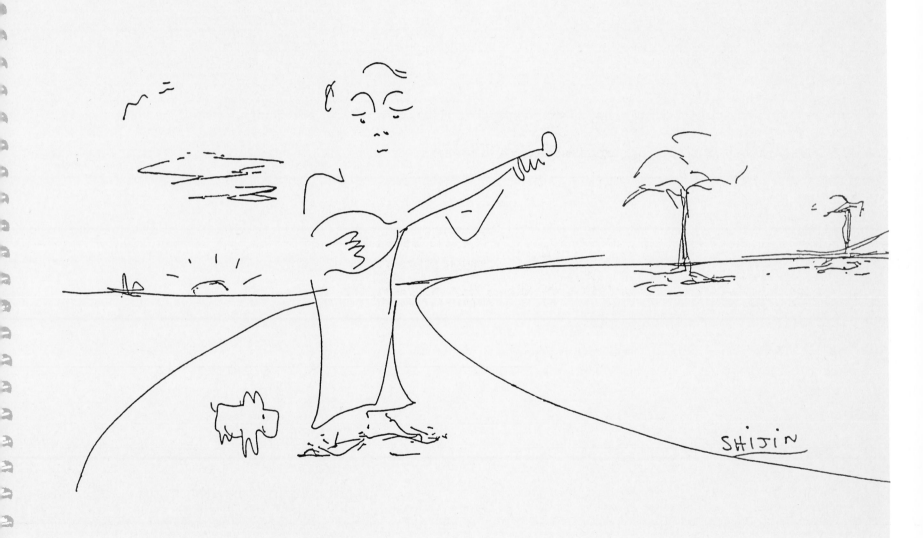

音楽家
ongakuka

musician

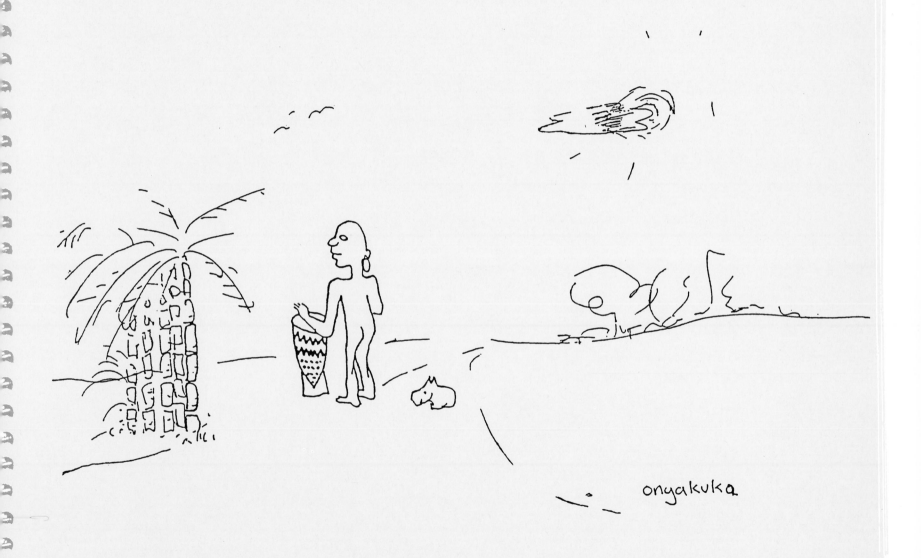

onyakuka

作ります　　　　　使います

tsukurimasu　　　　tsukaimasu

create　　　　　　use

歌を作るとき、ピアノを使います。

Uta o tsukuru toki, piano o tsukaimasu.

When I create a song, I use a piano.

TSUKURIMASU

uta o tsukuru toki piano o tsukaimasu TSUKAIMASU

お父さん
o-tō-san

daddy

お母さん
o-kā-san

mommy

息子
musuko

son

娘
musume

daughter

(ご)家族
(go)kazoku

family

ぼくの家内です。
Boku no kanai desu.

This is my wife.

私の主人です。
Watakushi no shujin desu.

This is my husband.

BOKUNO KANAI DESU —

OTOSAN

OKĀSAN

— WATAKUSHI NO SHUJIN DESU

ICH BIN EINE BERLINER

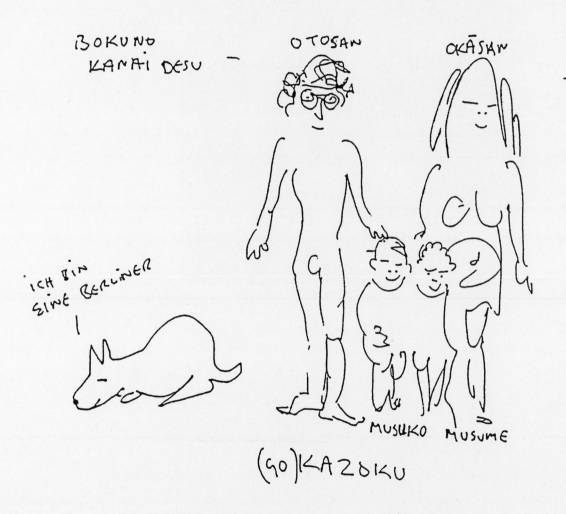

MUSUKO MUSUME

(GO)KAZOKU

Photo by J.L.

2
To Japan

荷作り(します)。
Nizukuri (shimasu).

(I'm going to) pack.

洗面道具
senmendōgu

toiletries

NIZUKURI. (SHIMASU)

Senmendōgu

予約（したいです）。

Yoyaku (shitai desu).

(I'd like to make a) reservation.

もしもし、ホテル馬鹿ですか?

Moshi moshi, Hoteru Baka desu ka?

Hello, is this the Hotel Foolish?

YOYAKU (SHITAI DESU)

Reserve.

Moshi moshi Hotel Bakka desuka?

馬鹿航空
Baka Kōkū

Foolish Airline

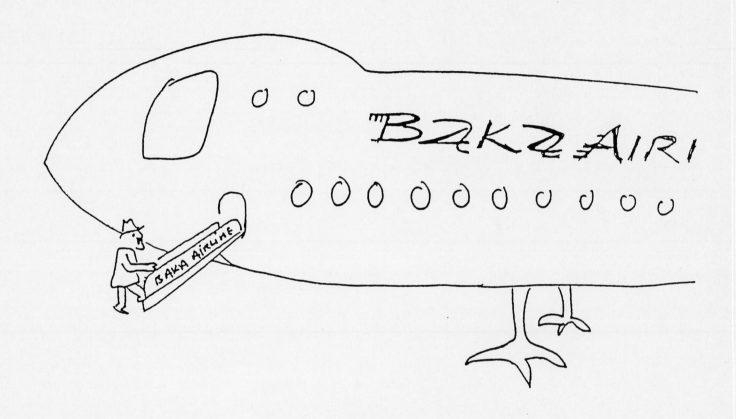

目的地はどこですか?

Mokutekichi wa doko desu ka?

What is your destination?

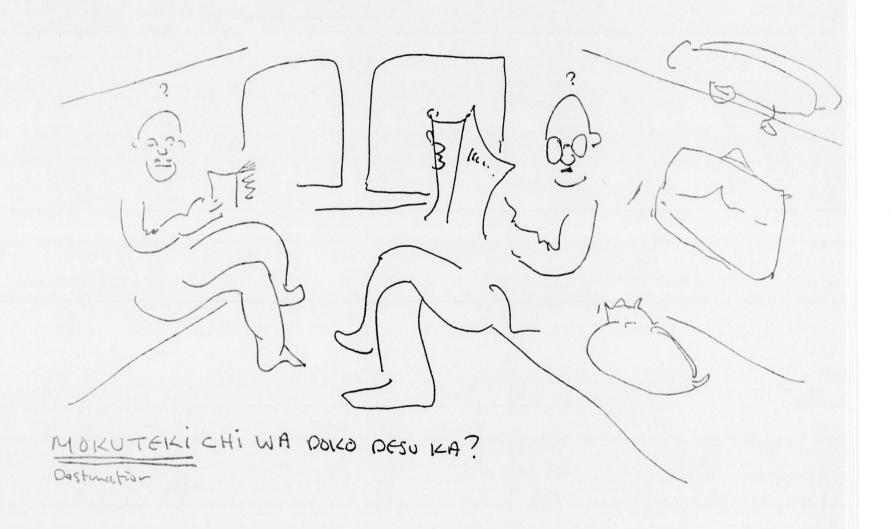

MOKUTEKI CHI WA DOKO DESU KA?

Destination

着きます

tsukimasu

arrive

TSUKIMASU

握手する
akushu suru

shake hands

しばらくでしたね?
Shibaraku deshita ne?

It's been a while, hasn't it?

AKUSHU (suru)

Photo by J.L.

3
Everyday Life

眠る
nemuru

sleep

NEMURU

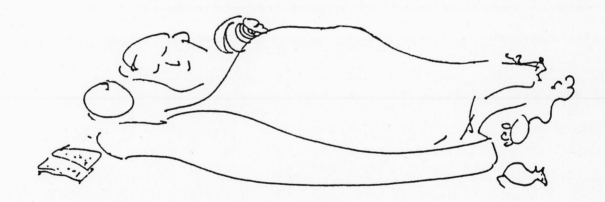

顔を洗います

kao o araimasu

歯をみがきます

ha o migakimasu

wash face

brush teeth

KAO O ARAIMASU

hao migakimasu

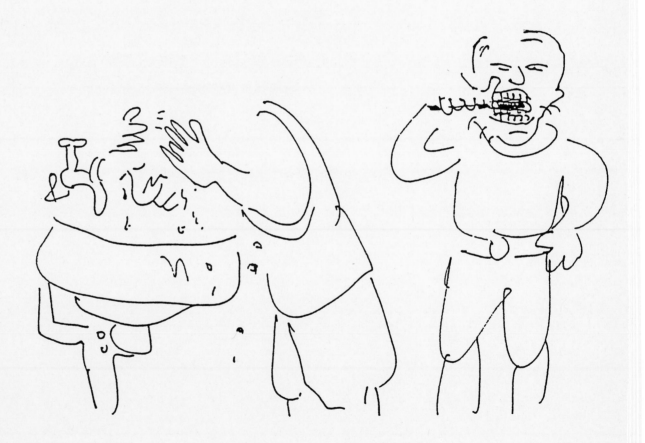

雑誌を読んでいます

zasshi o yondeimasu

reading a magazine

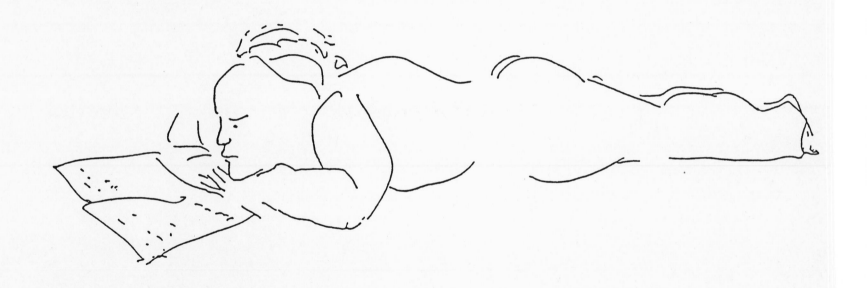

ZASSHIO YONDEIMASU

テレビを見ています

terebi o miteimasu

watching television

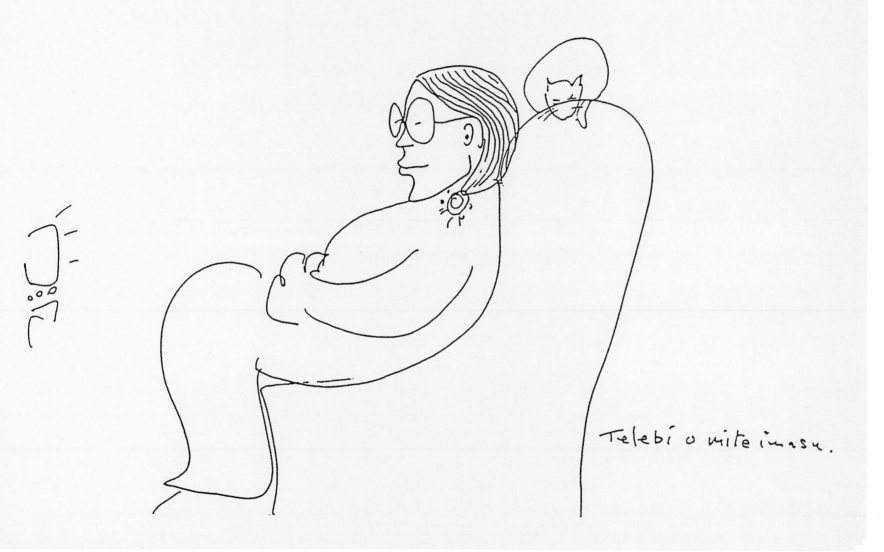

夢を見ながら本を読んでいます

yume o minagara hon o yondeimasu

reading a book while dreaming

YUMEO MINAGARA HONO
YONDE IMASU

いつも
itsumo

always

ごはん　　みそ　　やさい
gohan　　miso　　yasai

rice　　miso　　vegetables

iTSUMO

GOHAN
MISO
YASAI

（いちどに）食べます

(ichido ni) tabemasu

eat (all at once)

(ICHI DO NI) TABEMASU

食べながら話しません!!

Tabenagara hanashimasen!!

We don't talk while eating!!

TABE NAGARA
HANASHIMASEN!!

Photo by J.L.

4

Rules

生きる　　　死ぬ

ikiru　　　shinu

live　　　die

ikiru.

shinu

男性　　　　女性

dansei　　　josei

man　　　woman

DANSEI

JOSEI

1976年12月

issen-kyūhyaku-nanajū-roku nen, jū-ni gatsu

1976, December

1976 = i sen kyu hyaku nana ju roku nen
Dec = ju ni gatsu.

日曜日
Nichiyōbi

Sunday

("Sun" Day)

月曜日
Getsuyōbi

Monday

("Moon" Day)

火曜日
Kayōbi

Tuesday

("Fire" Day)

水曜日
Suiyōbi

Wednesday

("Water" Day)

木曜日
Mokuyōbi

Thursday

("Wood" Day)

金曜日
Kinyōbi

Friday

("Metal" Day)

土曜日
Doyōbi

Saturday

("Earth" Day)

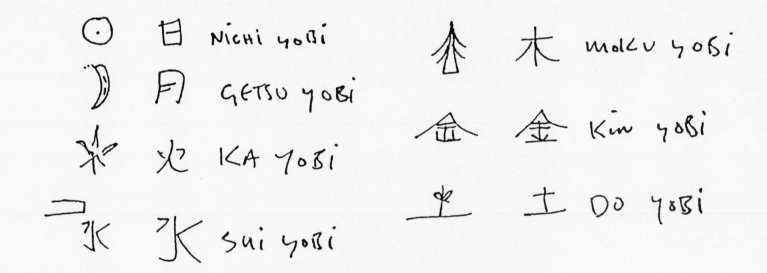

⊙　日　NICHI YOBI

☽　月　GETSU YOBI

米　火　KA YOBI

氺　水　SUI YOBI

木　木　MOKU YOBI

金　金　KIN YOBI

土　土　DO YOBI

ここから家は<u>近い</u>です。（しかし／が）ここから月は<u>遠い</u>です！

Koko kara uchi wa <u>chikai</u> desu. (Shikashi/ga) koko kara tsuki wa <u>tōi</u> desu!

From here home is <u>near</u>, (but) from here the moon is <u>far</u>!

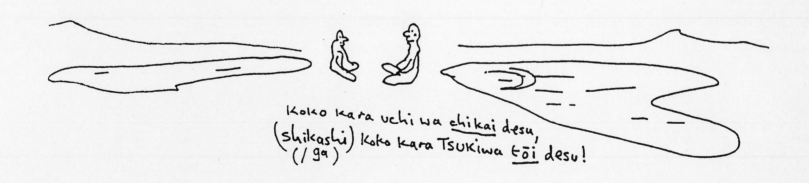

Koko kara uchi wa <u>chikai</u> desu,
(shikashi) Koko kara TSUKiwa <u>tōi</u> desu!
(/ga)

北
hoku (kita)

north

西 　　　　　　　　　　　　　 東

zai (nishi) 　　　　　　　 tō (higashi)

west 　　　　　　　　　　　 east

南

nan (minami)

south

HOKU
(KITA)

ZAI
(NISHI) ← → TO
(HIGASHI)

NAN
(MINAMI)

上　　　　上がります

ue　　　　agarimasu

up　　　　going up

下　　　　下がります

shita　　　sagarimasu

down　　　going down

ELEVATOR

(up) agarimasu
UE

'(Down) sagarimasu
SHITA (under)

だんだん高くなります

dandan takaku narimasu

gradually getting higher

DANDAN TAKAKU NARIMASU.

比べる

kuraberu

compare

遅い　　　　速い

osoi　　　　hayai

slow　　　　fast

カメはウサギに比べて<u>遅い</u>です。

Kame wa usagi ni kurabete <u>osoi</u> desu.

Compared to a rabbit, a turtle is <u>slower</u>.

ウサギはカメに比べて<u>速い</u>です。

Usagi wa kame ni kurabete <u>hayai</u> desu.

Compared to a turtle, a rabbit is <u>faster</u>.

KURABERU

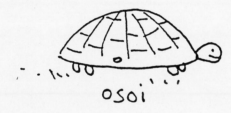

OSOI

HAYAI

OKAMEWA USAGINI KURABETE <u>OSOI</u> DESU
✿USAGIWA KAMENI KURABETE <u>HAYAI</u> DESU

航空便

kōkū bin

air mail

船便

funa bin

sea mail

切手

kitte

stamp

KŌKŪ BIN

FUNA BIN

電気(が)ついています
denki (ga) tsuiteimasu

the light is on

電気をつけます
denki o tsukemasu

turn on the light

電気(が)消えています
denki (ga) kieteimasu

the light is off

電気を消します
denki o keshimasu

turn off the light

つける
tsukeru

消す
kesu

turn on

turn off

Denki (ga)

Tsui te imasu
Ki ete imasu

denki o Tsuke masu
" " keshi masu.

turn on } TSUKERU
turn off } KESU

減る　　　ふえる

heru　　　fueru

decrease　　increase

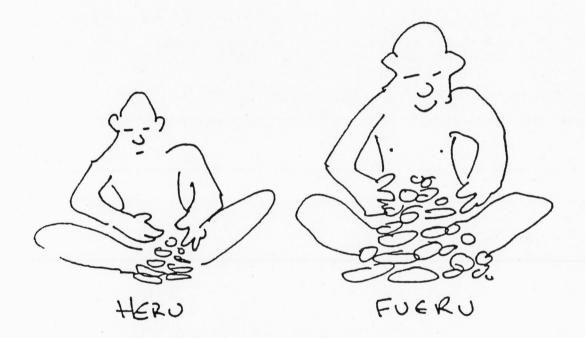

HERU　　　　FUERU

なくす

nakusu

lose

全部なくしました！

Zenbu nakushimashita!

I have lost everything!

NAKUSU

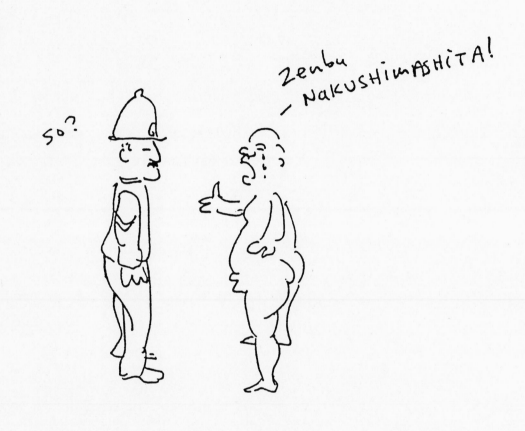

見つかる

mitsukaru

to be found

全部見つかりました！

Zenbu mitsukarimashita!

Everything has been found!

どうもありがとう。

Dōmo arigato.

Thank you very much.

MITSU KARU

親切 　　　　(不)親切

shinsetsu 　　(fu)shinsetsu

kind 　　　　(not) kind

shinsetsu (Fu)shinsetsu.

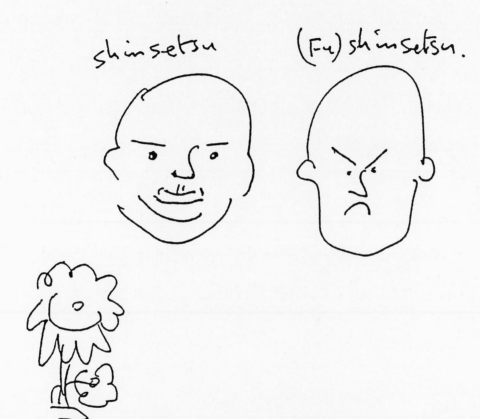

貸す
kasu

借りる
kariru

lend

borrow

（この）銀行はお金を貸します。
(Kono) ginkō wa o-kane o kashimasu.

(Our) bank will lend you money.

お金を借りたいです。お金を貸してください。
Okane o karitai desu. Okane o kashite kudasai.

I want to borrow money. Please lend me money.

アスピリンを飲みなさい！

Asupirin o nominasai!

Take an aspirin!

風邪をひいています。

Kaze o hiiteimasu.

I have a cold.

くすりばこ

kusuri bako

medicine chest

医者

isha

doctor

患者

kanja

patient

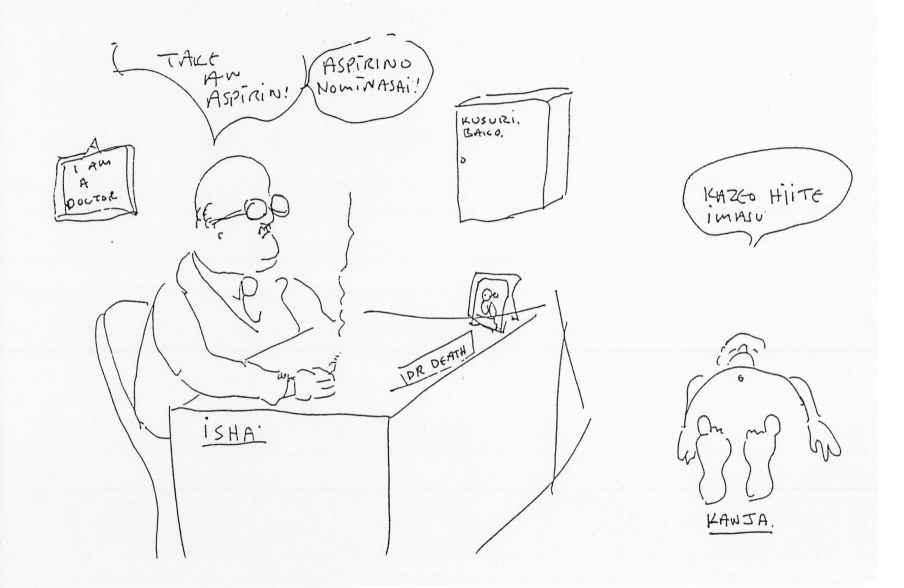

甘い	すっぱい	塩っぱい	からい	にがい
amai	suppai	shoppai	karai	nigai
sweet	sour	salty	hot	bitter

AMAI SUPPAI SHOPPAI KARAI NIGAI

真ん中
mannaka

center

MANNAILA.

Photo by J.L.

5
Society

極東

Kyokutō

Far East

アメリカ

America

U.S.A.

日本は輸出します。

Nippon wa yushutsu shimasu.

Japan exports.

USAは輸入します。

U.S.A. wa yunyū shimasu.

U.S.A. imports.

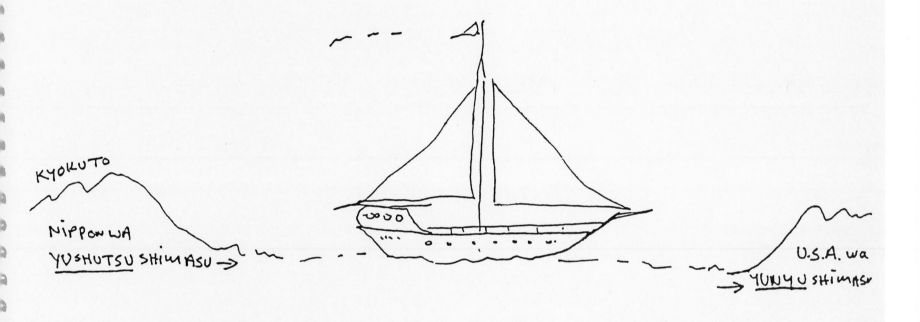

KYOKUTO

NIPPON WA
YUSHUTSU SHIMASU →

U.S.A. wa
→ YUNYU SHIMASU

よい取り引き!

Yoi torihiki!

Good deal!

鋼鉄とガラス

kōtetsu to garasu

steel and glass

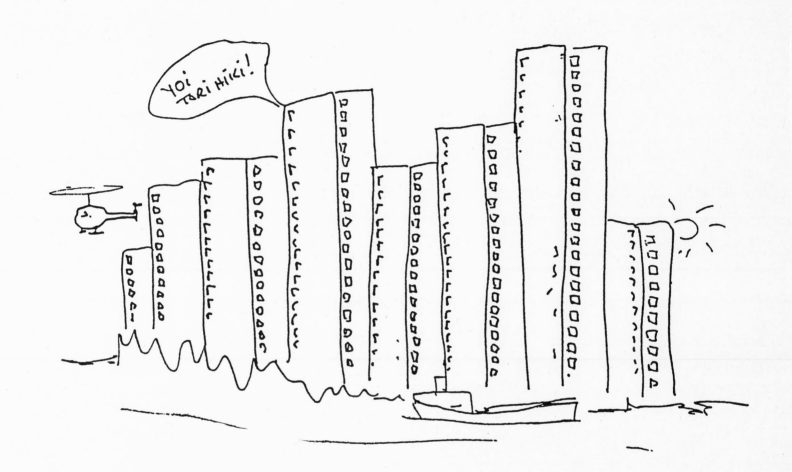

産業（発展しています）。

Sangyō (hatten shiteimasu).

Industry (is developed).

産業国

sangyō koku

industrial country

産業製品会社

Sangyō Seihin Gaisha

Industrial Products Co.

SANGYO

(HATTEN SHITEIMASU).

SANGYO·KOKU.

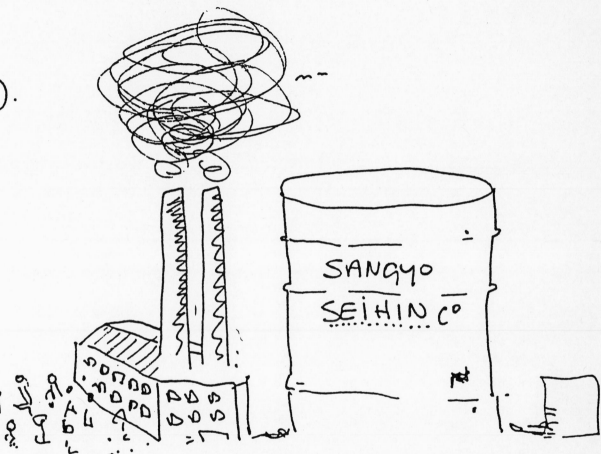

税金　　　　　払う　　　　　政府
zeikin　　　　harau　　　　　seifu

tax　　　　　to pay　　　　government

もしカメラを買えば、税金を払わなければなりません。
<u>Moshi</u> camera o kaeba, zeikin o harawanakereba narimasen.

<u>If</u> you buy a camera, you have to pay tax.

zeikin : TAX. **harau** To pay **SEIFU** : Government

moshi camera o kaebu zeikin o harawa nakereba narimasen

目上の人たち

meue no hito tachi

one's superiors

MEUÉ NO HITO TACHI

目下

meshita

one's inferiors

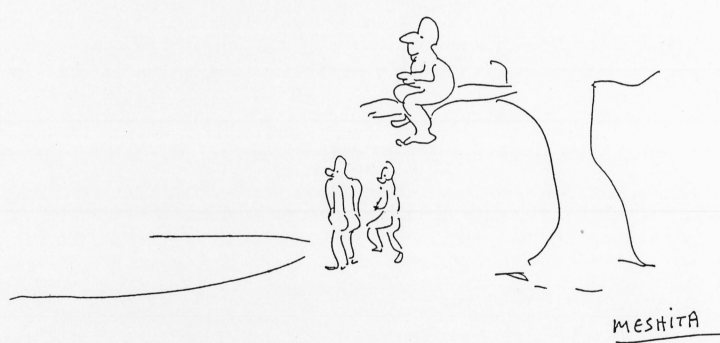

MESHITA

会議(をしています)

kaigi (o shiteimasu)

(having a) conference

会議中は話し合います。

Kaigi chū wa hanashiaimasu.

We talk to each other during the conference.

弁護士

bengoshi

lawyer

KAIGI
(O SHITE IMASU.)

KAIGI CHU WA
HANASHI AI MASU.

BENGOSHI

今日の経済はいいですね?

Konnichi no keizai wa ii desu ne?

Today's economy is good, isn't it?

経済は地獄ざたですね?

Keizai wa jigoku zata desu ne?

The economy is hell, isn't it?

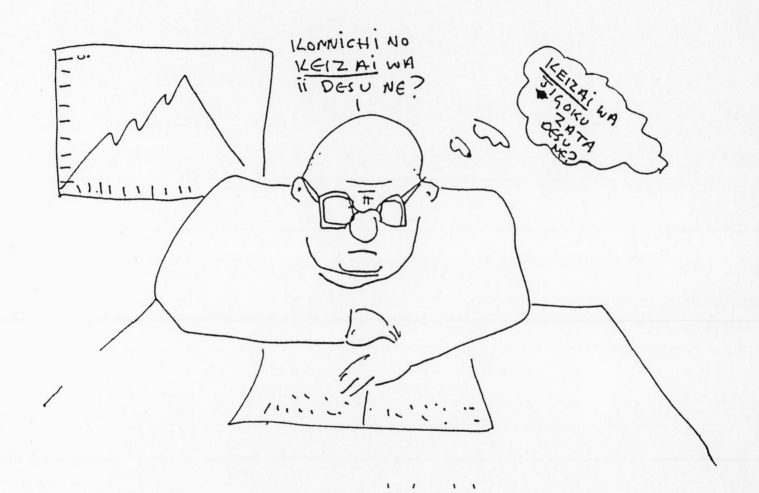

芸者の値段は上がります。

Geisha no <u>nedan</u> wa agarimasu.

The <u>price</u> of a geisha goes up.

GEISHA NO <u>NEDAN</u>WA AGARIMASU

もし映画をみたければ、切符を買わなければなりません。

Moshi eiga o mitakereba, kippu o kawanakereba narimasen.

If you want to see the movie, you must buy a ticket.

moshi eiga o mi ta kereba kippu o kawa nakereba narimasen

もし買いたければ、お金をもっていなければなりません。

Moshi kaitakereba, o-kane o motteinakereba narimasen.

If you want to buy it, you must have money.

moshi kai takereba okane o motte inakereba narimasen

またどうぞ、いらっしゃいませ。

Mata dōzo, irasshaimase.

Please come again.

ありがとうございました。

Arigatō gozaimashita.

Thank you very much.

ヘンな人ね？

Hen na hito ne?

He's a weirdo, isn't he?

漁夫
gyofu

fisherman

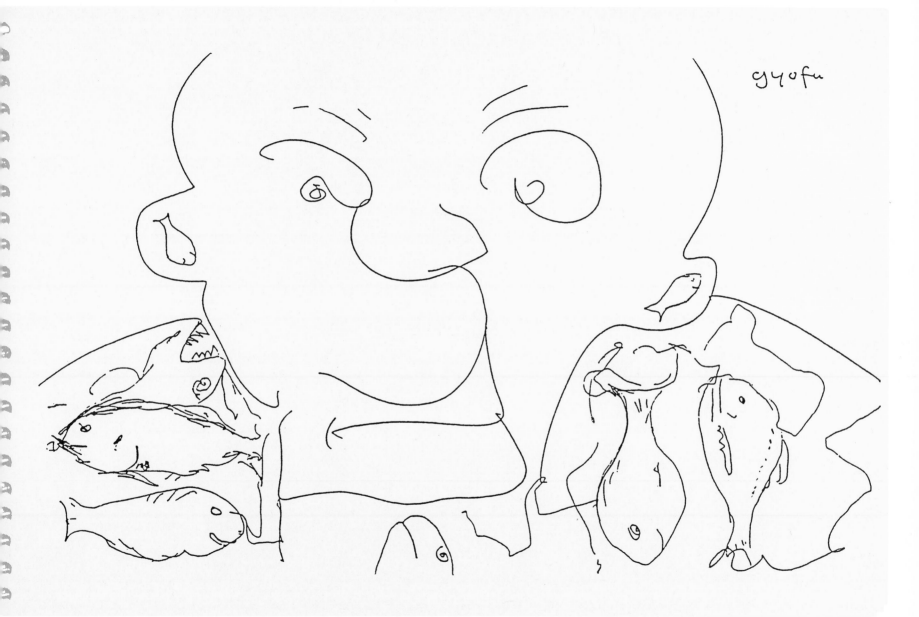

農夫

nōfu

farmer

農業

nōgyō

agriculture

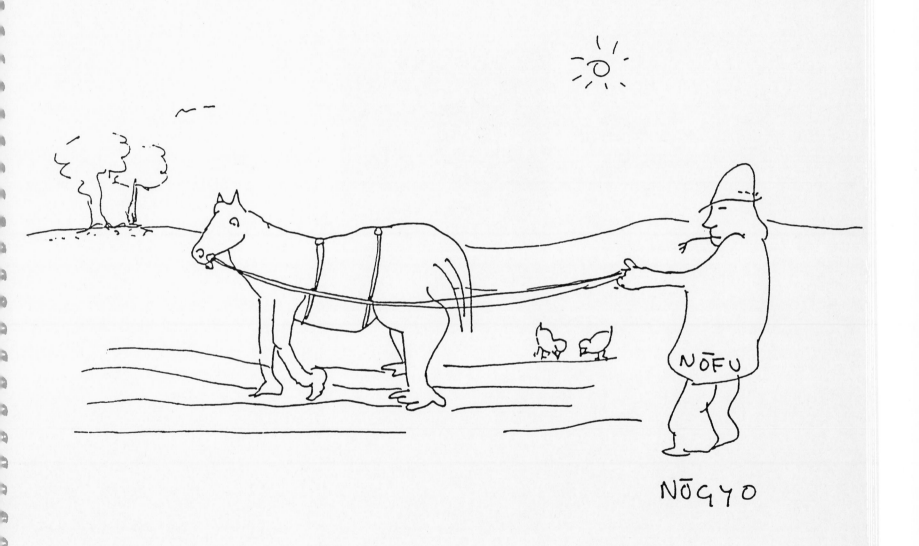

NŌGYO

Photo by J.L.

6

Acts

歩く
aruku

walk

ここ
koko

あそこ
asoko

here

there

泳ぐ
oyogu

swim

泳げば泳ぐほど、体にいいです。
Oyogeba oyogu hodo, karada ni ii desu.

The more you swim, the better it is for your body.

OYOGU

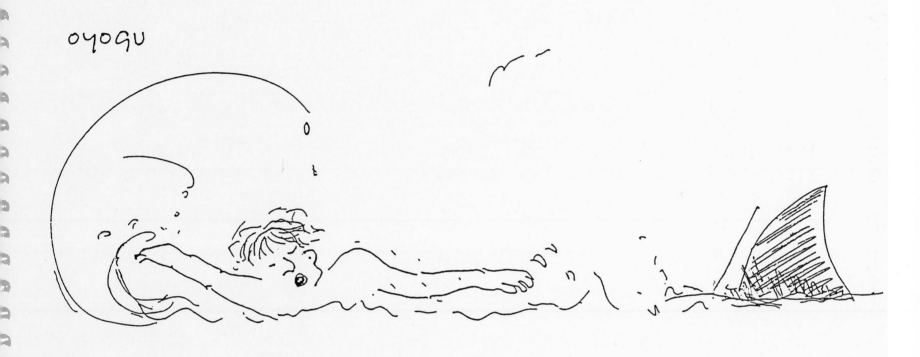

OYOGEBA OYOGU HODO KARADA NI ii DESU

砂遊び

suna asobi

playing with sand

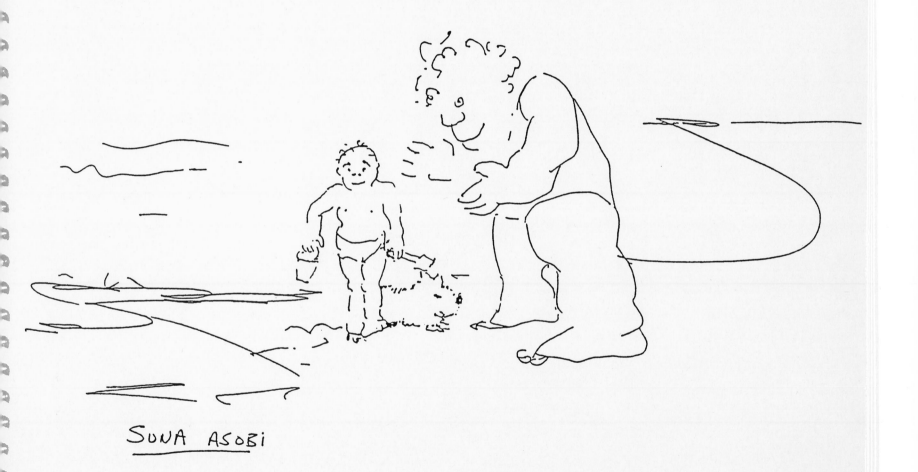

SUNA ASOBI

大声でどなる

ōgoe de donaru

shout out loud

OGOE de
DONARU

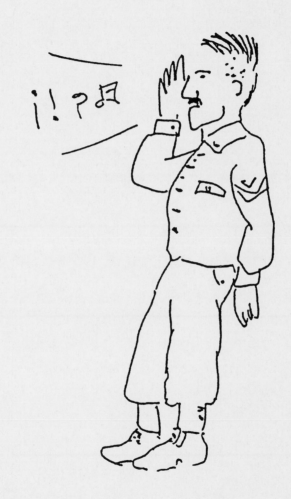

あげます

agemasu

くれます

kuremasu

もらいます

moraimasu

give (to someone)

(someone) give (to me)

receive

私は家内にあげます。

Watakushi wa kanai ni agemasu.

I give to my wife.

家内は私にくれます。

Kanai wa watakushi ni kuremasu.

My wife gives to me.

私は家内からもらいます。

Watakushi wa kanai kara moraimasu.

I receive from my wife.

AGEMASU KUREMASU MORAIMASU

watakushi wa
kanai ni
AGEMASU

KANAI WA
WATAKUSHI NI
KUREMASU.

Watakushi wa
Kanai Kara
MORAIMASU

なります ならします

narimasu narashimasu

ring ring

ベルがなります！ 私はベルをならします！

Beru ga narimasu! Watakushi wa beru o narashimasu!

The bell rings! **I ring the bell!**

NARIMASU

Bell _ga_ narimasu!

NARASHIMASU

watakushi wa bell o narashimasu!

着る

kiru

wear

シープを着ています。

Sheep o kiteimasu.

She's wearing a sheep.

KIRU
SHEEPO KITE IMASU

椅子にかけて、電話をかけます。

Isu ni kakete, denwa o kakemasu.

He sits down in a chair and calls someone.

KAKERU.

ISU NI KAKETE DENWA O KAKEMASU

体重をはかります。

Taijū o hakarimasu.

He weighs himself.

TAIJU O <u>HAKARIMASU</u>

泣く

naku

cry

願い

negai

a wish

(願う)

(negau)

(to wish)

NÈGAI

(NEGAU)

Photo by J.L.

7
Teachings

Shibumi, Sabi, and *Wabi*

The following three words, *shibumi, sabi,* and *wabi* are shown here
without their translations. These are words that really do not have their
equivalent in English, though if you open a dictionary, you would prob-
ably find some attempt made to translate them. *Shibumi, sabi,* and
wabi are in varying degrees words which express beauty that is not
extravagant in its form or substance. The closest words I could think
of in English are the contemporary slang words "cool" and "bad,"
except *shibumi, sabi,* and *wabi* are products of old Japan. At the time,
with the influence of Zen Buddhism, feudal wars, and repression,
people went for understated beauty and sensitivity, reflecting the deso-
late and transient feelings which pervaded their lives. These three
words then became part of our culture and have influenced our think-
ing pattern in a big way. Without understanding *shibumi, sabi,* and
wabi, it is hard to appreciate our cultural upbringing, our thought
patterns, music, literature, theater, or art.

 Y.O.

しぶみ
shibumi

shibumi

SHIBUMI

さび
sabi

sabi

SABI

わび
wabi

wabi

おしのび
o-shinobi

incognito

OSHINOBI

お元気でいらっしゃいますか？

O-genki de irasshaimasu ka?

Are you doing well?

おかげさまで!!

O-kage-sama de!!

Yes, thank you (and all the others)!!

Photo by J.L.

8
Life's Lessons

道に迷いました。どうぞ教えて下さい。

Michi ni mayoimashita. Dōzo oshiete kudasai.

I am lost. Please show me the way.

MICHI NI
MAYOI MASHITA —
DOZO OSHIETE KUDASAI.

道に穴があって危ないです。

Michi ni ana ga atte abunai desu.

It's dangerous 'cause there's a hole in the road.

危ないです!!

Abunai desu!!

Dangerous!!

MICHI NI ANAGA **A'TTE** ABUNAI DESU

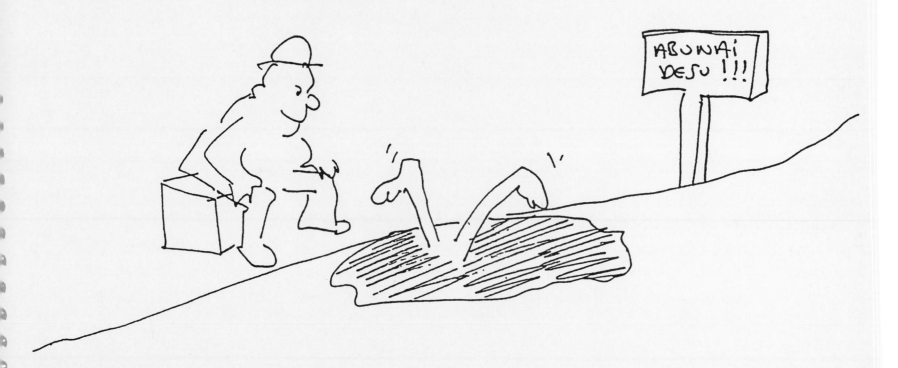

難しい

muzukashii

difficult

手で歩くのは難しいです。

Te de aruku no wa muzukashii desu.

Walking on your hands is difficult.

MUZU KASHii

TE DE ARUKU NO WA
MUZU KASHii DESU

べきです

beki desu

should

べきではありません

beki de wa arimasen

should not

とんでみるべきです！

Tonde miru beki desu!

You should try to fly!

とぶべきではありません！

Tobu beki de wa arimasen!

You should not fly!

歩くべきです！

Aruku beki desu!

You should walk!

毎日生まれかわります。

Mainichi umarekawarimasu.

We are born anew everyday.

mainichi umaré kawarimasu

なんでも知っている顔
nan de mo shitteiru kao

a face that knows all

NAN DEMO
SHITTE IRU KAO

さとっている顔

satotteiru kao

a face that is enlightened

SATOTTE
IRU KAO

知ってれば知っているほど、話したがらない。

Shittereba shitteiru hodo, hanashitagaranai.

The more you know, the less you want to talk.

知らなければ知らないほど、話したがる。

Shiranakereba shiranai hodo, hanashitagaru.

The less you know, the more you want to talk.

SHITTEREBA SHITTE IRU _HODO_ HANASHITAGARANAI
SHIRANAKEREBA SHIRANAI _HODO_ HANASHITAGARU

変える
kaeru

change

変わる
kawaru

change

私は 考えを 変えました。
Watakushi wa kangae o kaemashita.

I changed my mind.

考えは 変わりました。
Kangae wa kawarimashita.

My mind has changed.

Kaeru (change) KAWARU.

WA (KANGAE) O KAE MASHITA

(KANGAE) WA KAWARI MASHITA

なおす

naosu

correct

まちがえれば、正しくなおします。

Machigaereba, tadashiku naoshimasu.

If I make a mistake, I correct it.

NAOSU.

MACHI GAEREBA TADASHIKU NAOSHIMASU

少しずつ
sukoshi zutsu

little by little

SUKOSHI ZUTSU

取り引きしません。

Torihiki shimasen.

I don't <u>deal</u>.

TORIHIKI SHIMASEN

気楽(です)。
Kiraku (desu).

(I'm taking it) easy.

KIRAKU (DESU)

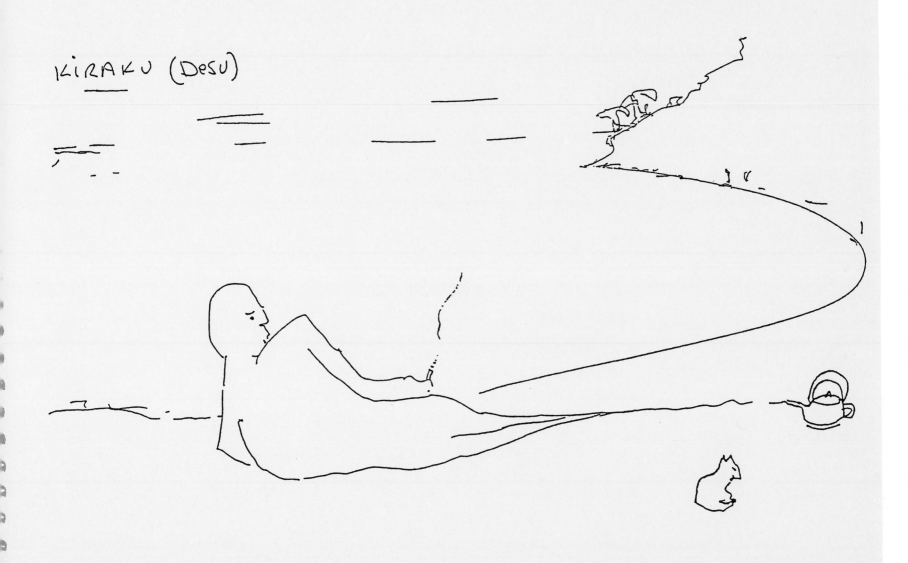

美しい
utsukushii

beautiful

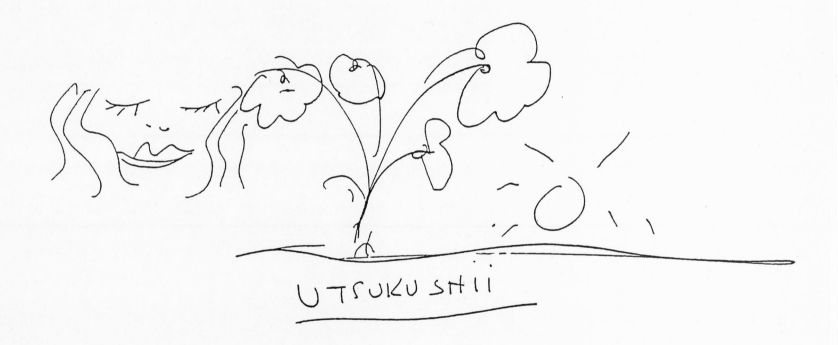

UTSUKUSHII

終わります

owarimasu

finish

OWARIMASU

おだいじに!

O-daiji ni!

Take care!

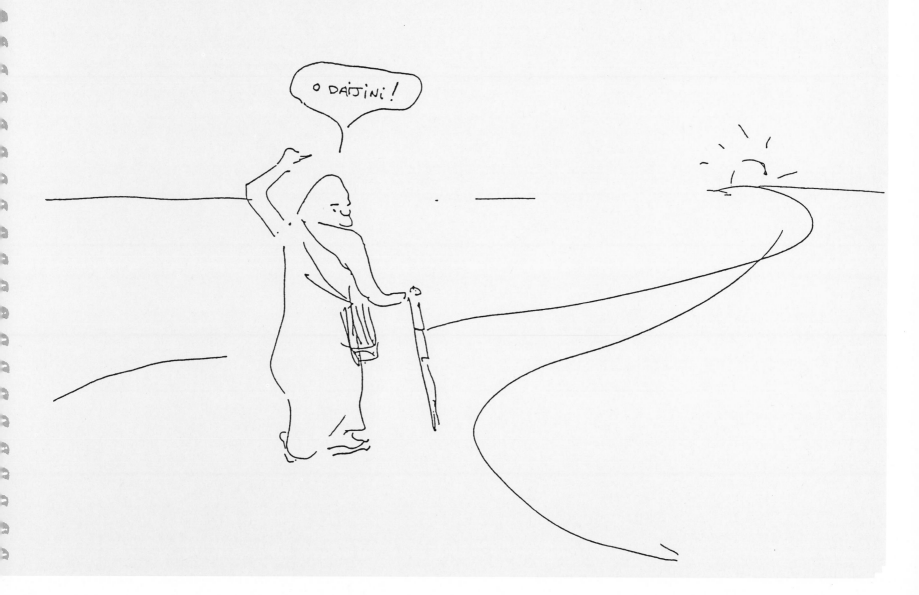

love

ai

Photo by J.L.

日本語を話せば話すほど、上手になります。

Nippongo o hanaseba hanasu hodo, jōzuni narimasu.

**The more you speak Japanese,
the better you speak it.**

NIPPONGOO
HAWASEBA HANASU HODO
JOZUNI NARIMASU.